SOHO IN THE
FIFTIES AND SIXTIES

Jonathan Fryer

NPG

Published in Great Britain by National Portrait Gallery Publications,
National Portrait Gallery, St Martin's Place, London WC2H 0HE

ISBN 1 85514 234 1

A catalogue record for this book is available from the British Library

Series Project Editors: Celia Jones and Lucy Clark
Series Picture Researcher: Susie Foster
Series Designer: Karen Osborne
Printed by Clifford Press Ltd, Coventry

Front cover
John Deakin, 1912–72
Luke Kelly, *c.*1970 (detail)
Matt cibachrome print, 29.1 x 26.3cm
© Luke Kelly
National Portrait Gallery (x68944)

For a complete catalogue of current publications,
please write to the address above.

CONTENTS

❦

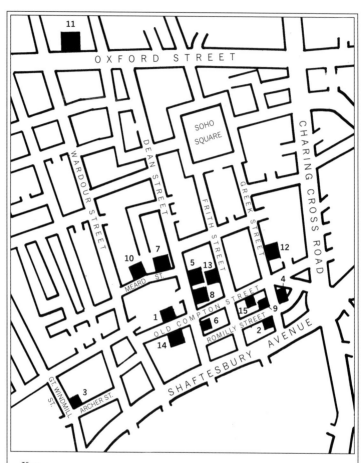

INTRODUCTION

❧

According to popular tradition, Soho gets its name from a now disused hunting cry, 'Soho!', along the lines of 'Tally-Ho!' Whatever the truth of that, it charmingly conjures up the idea of a semi-rural environment very different from that of the area today. Seventeenth-century men such as property developer Richard Frith and Henry Compton, Bishop of London (who was involved in building the church of St Anne), whose legacy is reflected in street names, put paid to any remaining greenery, with the exception of Soho Square.

Formally, there is no fixed boundary to Soho. It blends into Fitzrovia to the north, Chinatown to the south, Piccadilly to the west and Bloomsbury to the east, but the most commonly accepted delineation of Soho puts it within a rough rectangle marked out by Shaftesbury Avenue, Regent Street, Oxford Street and the Charing Cross Road. Its heart is the tight little grid of streets north and south of Old Compton Street.

From its early days, Soho attracted immigrants and transients: French Huguenots, Jews, Italians and the flotsam and jetsam of a cosmopolitan society that decided to opt for the West End of London rather than the East End, mainly because there were more 'toffs' to be found there. Soho's reputation as a home for vice (as well as cheap foreign food and copious drink) was early sealed. Among late Victorian *aficionados* was Oscar Wilde, who dangerously entertained his young 'panthers' in private rooms at Kettners, before his downfall.

During the height of the Second World War, central London was awash with British and Allied servicemen, enjoying precious hours of leave, never knowing whether these would be their last. There was an urgency about the need for entertainment and companionship. Brief encounters, straight and gay, occurred in the blackouts. In the early 1950s some of that febrile atmosphere persisted. Soho was an ideal place to escape the aura of austerity that still pervaded so much of the country. Moreover, with foreign travel still difficult, Soho was the next best thing to 'abroad', with its continental bakeries, its wide gastronomic range and its veneer of sin.

MAP OF SOHO

It is surely no coincidence that many of the key figures in Soho in the 1950s and 1960s spent time in Paris before the war. Artists such as Nina Hamnett (1890–1956), Francis Bacon (1909–92) and John Minton (1917–57) found inspiration there; all discovered a sense of liberation, which could be at least partly recreated in the vigorous, bohemian scene of Soho. Drink, food and more drink kept them going. One of Soho's greatest attractions, in an era of highly restrictive licensing hours, was that it had afternoon drinking clubs, after-hours bars and, for the real night-owls, taxi-drivers' cafés and other places which could provide at least a cup of tea and a bacon sandwich.

It is striking how few of the great Soho figures of the 1950s and 1960s actually lived there, with the exception of Gaston Berlemont (born 1914) at the French Pub in Dean Street (officially called the York Minster), who was raised and resided on the premises. A few, like Lucian Freud (born 1922), Caroline Blackwood (1931–96) and Henrietta Moraes (1931–99), became temporary residents, but most preferred to commute in–usually by taxi (true Sohoites seemed to have an inexplicable aversion to public transport). The Soho day began with pub opening time, or else at lunch time. The self-disciplined, like Francis Bacon, would have put in a morning's real work before arriving, the more weak-willed would only just have got up. From then on, there were a number of itineraries that could be followed, with the main pubs, restaurants and clubs all within easy walking distance for all but the most inebriated.

There were dozens of places to choose from. Some people, like Jeffrey Bernard (1932–97) at the Coach and Horses in Greek Street, staked out their territory with the precision of the most determined cat, but most would have a number of favoured drinking-holes, where they knew they would meet friends and would find a ready topic of conversation in the debate as to where they should go next. The characters who ran these various haunts were an essential element in their attraction. Gaston Berlemont at the French Pub, like his father before him, had a genial style of hospitality that complemented the rather homely atmosphere of the place, with its signed photographs of actors, writers, artists and boxers on the walls. Football supporters and other interlopers would wander in and then out again, mystified by a place that had Pernod on tap, but not beer.

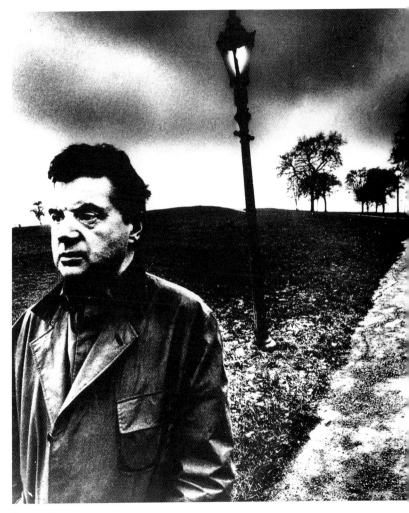

FRANCIS BACON
Bill Brandt, 1963

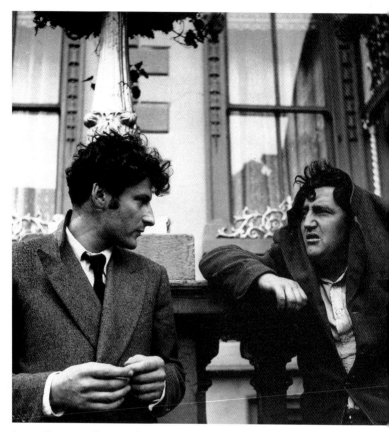

LUCIAN FREUD AND BRENDAN BEHAN, Daniel Farson, 1952

Norman Balon, landlord at the Coach and Horses, prided himself on his rudeness, which was only capped by the more stylish, obscenity-laden performance of Muriel Belcher (1908–79), who ran the members-only Colony Room. Immortalised in prose by Colin MacInnes (1914–76) and others, Muriel Belcher and her tatty club are now recognised as having been quintessential Soho, riding the cusp between stimulating originality and gross sordidness. In an article in the literary and political magazine *Encounter*, MacInnes nicely captured the thrilling decadence, tinged with very British guilt, of frittering away a summer's afternoon in the Colony Room:

> *To sit with the curtains drawn at 4 p.m. on a sunny afternoon, sipping expensive poison and gossiping one's life away, has the futile fascination of forbidden fruit: the heady intoxication of a bogus Baudelairean romantic evil. As the gin slips down your throat, and the dim electrics shine on the potted plants and on [Muriel's] lurid colour scheme of emerald green and gold, you feel like the fish in the tank above the cash register – swimming aimlessly among artificial water-weeds, mindless in warm water.*

MacInnes was partly drawn to Soho by the large number of Africans and West Indians who hung out there. He would usually have one in tow, just as John Minton went around with an entourage of sailors. Forty years on, that black presence has almost been forgotten. But black men were evident on almost every Soho street corner at the time, and several found employment at Ronnie Scott's (1927–96) jazz club.

The jazzman and comic George Melly (born 1926) has made many perceptive observations about Soho in the 1950s and 1960s, calling it at one point, 'that dodgy never-never land, that hallucinated enclave, where we waited, consumed by angst, to cure today's hangover by making certain of tomorrow's'. Even more powerful than the written descriptions, though, are the visual images left, especially the black-and-white photographs of John Deakin (1912–72) and Dan Farson (1927–97).

Most of the old Soho personalities are dead. Many of the famous places, like the Gargoyle Club and the Mandrake on Meard Street, are closed. Some, like the Colony Room and the French Pub (now called the French House) linger on under new management. New places have opened up, revitalising Soho after the dire years of the porn-dominated

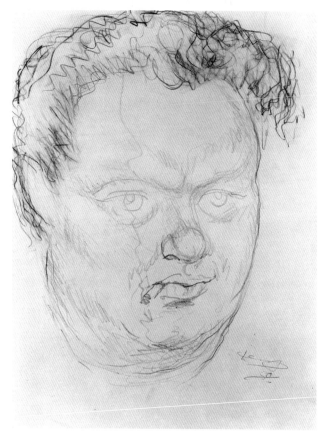

DYLAN THOMAS, Mervyn Levy, 1950

1970s. Peter Boizot at Kettners Restaurant has given an injection of life into the area's jazz. Terence Conran has brought in fashionable mega-dining at Mezzo in Wardour Street. The Groucho Club is thronged by trendy media people wanting to be seen. And Old Compton Street has become a gay ghetto. As ever, Soho is on the move.

SELECT BIBLIOGRAPHY

Daniel Farson, *Never a Normal Man*, HarperCollins, 1997.

Daniel Farson, *Soho in the Fifties*, Michael Joseph, 1987.

Jonathan Fryer, *Dylan*, Kyle Cathie, 1993.

Tony Gould, *Inside Outsider*, Chatto & Windus, 1983.

Denise Hooker, *Nina Hamnett, Queen of Bohemia*, Constable, 1986.

Graham Lord, *Just the One*, Sinclair-Stevenson, 1992.

George Melly, *Owning Up*, Weidenfeld & Nicolson, 1965.

Henrietta Moraes, *Henrietta*, Hamish Hamilton, 1994.

Robin Muir, *John Deakin: Photographs*, Shirmer/Mosel, 1996.

Ulick O'Connor, *Brendan Behan*, Hamish Hamilton, 1970.

Michael Peppiatt, *Francis Bacon*, Weidenfeld & Nicolson, 1996.

Ronnie Scott, *Some of My Best Friends Are Blues*, W. H. Allen, 1979.

Frances Spalding, *Dance till the Stars Come Down: A Biography of John Minton*, Hodder & Stoughton, 1991.

Judith Summers, *Soho*, Bloomsbury, 1989.

Richard Tames, *Soho Past*, Historical Publications, 1994.

DYLAN THOMAS (1914–53)

❦

Nurtured in that most anglicised of South Wales suburbs, Uplands in Swansea, the young poet Dylan Thomas had not long been in Soho before he realised the advantages of becoming a professional Welshman. His voice may have kept its cut-glass tones, so cherished by millions of listeners to the BBC Home Service, but his pub-yarns were of Welsh miners, washing in tin baths before the kitchen fire, incest in the valleys and delinquent Nonconformist ministers. With such tales, he kept his Soho audiences rapt, an ever-growing line of beer glasses snaking across the bar counter in front of him. His fiery, Irish wife Caitlin, when present, would yawn when a story she knew all too well resurfaced, or else kick him in the shins.

Dylan's main Soho days had been pre-war, when, overgrown schoolboy that he was, he revelled in the naughtiness and drank himself into a stupor, afterwards cuddling up, foetus-like, in the bed of any woman who had taken pity on him and invited him back home. He is still boyish in Rupert Shephard's 1940 oil, whereas the drawing by his childhood friend Mervyn Levy done ten years later shows the forces of self-destruction setting in.

Like so many of Soho's characters, Dylan was a chameleon. Away from the bars and the audience that clamoured for him to perform, he was highly disciplined, concentrated and immensely serious about his work – that essential seriousness can be glimpsed in the photograph of him seated before a BBC microphone (see p.14). He wrote nothing in Soho; it was his playground and the stage for his clowning. But in Wales, and occasionally on trips abroad, he did produce, laboriously mulling over every word and eschewing all drink until he felt his day's quota was done.

Sometimes, though, especially towards the end, the boisterousness of his bohemian life got the better of him. In October 1953, while on his final Soho binge, he left the typescript of his last and most enduring work *Under Milk Wood* in the Admiral Duncan pub in Old Compton Street, prompting a frantic – and fortunately successful – search by his BBC producer Douglas Cleverdon.

DYLAN THOMAS, Rupert Shephard, 1940

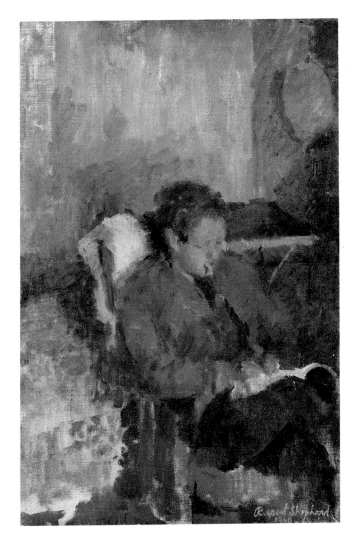

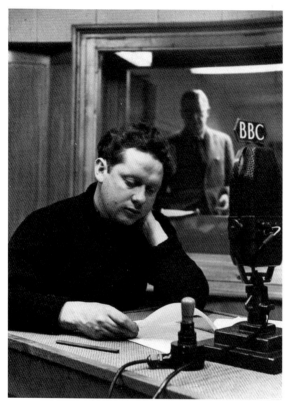

DYLAN THOMAS, John Gay, 1948

Caitlin had intimations of disaster when Dylan flew off to America a few days later; the radio-play was to be given a public reading in New York. Their marriage was falling apart, and so was Dylan. Within a month, he would be dead. Caitlin flew over to New York where he lay dying, assaulted one of the nuns looking after him, smashed a statue of the Virgin Mary, and was bundled off in a straitjacket – details that were much discussed and savoured in Soho bars for years to come.

NINA HAMNETT (1890–1956)

In the 1950s Nina Hamnett was a lady with a past, which she vaunted and flaunted from one end of Soho and Fitzrovia to the other. Herself a painter of undoubted early talent, she had been the model and the mistress of a string of first-rate artists on both sides of the English Channel. In her sixties, the past had become an investment, on which she drew dividends in the pubs of Soho and neighbouring areas, rattling a tobacco tin into which friends and strangers alike were expected to drop coins that would contribute to the next double gin.

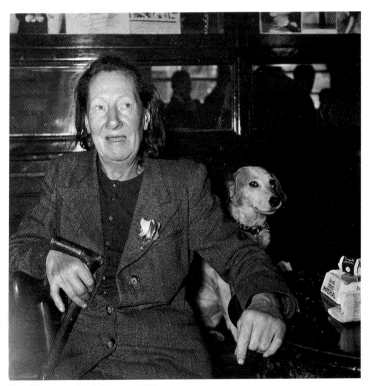

NINA HAMNETT, Daniel Farson, 1952

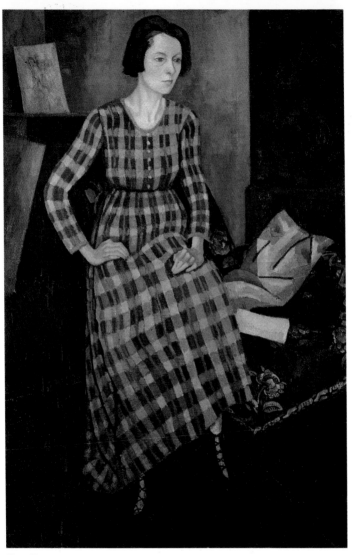

NINA HAMNETT, Roger Fry, 1917

In return, she reminisced. Of the Omega Workshops, of Henri Gaudier-Brzeska, of Walter Sickert and the Ballets Russes. She had a wicked way with anecdotes, charming Dylan Thomas one day, when he introduced her to the poet Ruthven Todd, with the breezy announcement: 'You know me, m'deah, I'm in the V and A with me left tit knocked off' (a reference to Gaudier-Brzeska's famous torso of her). Her first, scandalous volume of autobiography, entitled *Laughing Torso* (1932), had been savaged by the cub reporter Dylan Thomas in a review in the *South Wales Evening Post*, where he incorrectly claimed the book had been banned. The newspaper was threatened with legal action and Dylan lost his job, having to fall back on poetry. But in Soho, past grudges were usually forgiven, if not forgotten.

Roger Fry's 1917 portrait of his then lover Nina shows a young woman who had not just beauty but style; she also had a zest for life that made Sickert's wife, for one, wish she could tone herself down. In the 1950s a flicker of the energy was still there, at least until mid-evening, but the looks and the style had both gone. In a word, she was decrepit, eking out her days in the French Pub in Dean Street, or the Swiss Tavern in Old Compton Street, while spending her nights in a sordid, bottle-filled bedsit in Westbourne Terrace, Paddington. The one thing that remained from her more genteel former life was her upper-class drawl, which many young people in the increasingly egalitarian post-war Britain found distinctly alienating.

Nina's artistic talent had also waned, a fact of which she was only too aware. As a poignant symbol of her ruined life, she could declare, 'I took my grey dress to the dry-cleaners and, my dear, it just shrivelled up because of the gin soaked into it over the years. All they gave me back was a spoonful of dust.' Dan Farson's photograph of Nina in the French Pub poignantly reproduces her declining state: half ageing bohemian, half bag-lady.

FRANCIS BACON (1909–92)

The first time Francis Bacon hit Soho he was sixteen years old and had been thrown out of his rather grand country home by his military father, who caught him trying on his mother's underwear. Already profligate, with a taste for champagne and expensive restaurants, the youth supplemented his meagre allowance by becoming a manservant, rent-boy and petty thief. Brief but intense stays in inter-war Berlin and Paris propelled Bacon towards art, much under the influence of Picasso; by the time he became a key post-war Soho figure, however, he had developed a highly distinctive, disturbing style (although he was without formal training), and a penchant for popes.

Muriel Belcher, launching her Colony Room in 1948, instantly acknowledged Francis Bacon's captivating gregariousness. She called him her favourite daughter and paid him ten pounds a week (plus countless free drinks) to introduce friends and acquaintances as potential members. With his 'gilded, gutter' life, as he called it, Bacon was at home in extraordinarily diverse circles, including those of top London society hostesses, boxers and crooks. Profoundly masochistic, he frequently appeared at his favourite bars and clubs covered in cuts and bruises, usually attributed to a slip on the bathroom floor.

The artist Anthony Bailey aptly characterised Bacon's 'pear-shaped face, that seems assembled of disparate elements: the forehead belonging to an ascetic thinker, the eyes to a tragic actor, the cheeks to a plump cherub'; the artist's physical ambiguity – powerful yet effeminate – lurks in the Barker sculpture. His features, highlighted by not always subtly applied make-up, fascinated artist friends including Lucian Freud and photographers such as Bill Brandt and John Deakin. Brandt's famous portrait of Bacon against the background of a desolate park (see p.7) is haunting, almost nightmarish, like so much of Bacon's own work. Reginald Gray's canvas captures some of the sitter's ambiguity and vulnerability.

Bacon's reputation soared during the 1950s and 1960s, as did the prices of his paintings, yet he remained faithful to his old haunts. Phenomenally generous, he would whisk groups of friends, admirers and casual acquaintances off to Wheeler's in Old Compton Street for oysters and the finest wines.

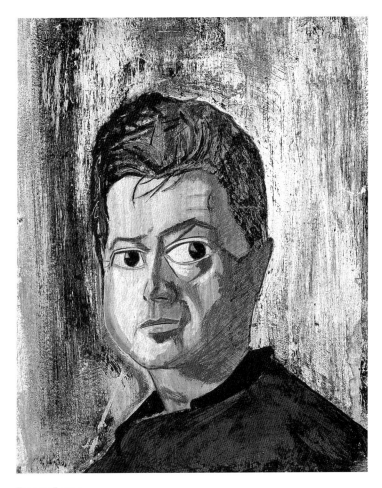

Francis Bacon
Reginald Gray, 1960

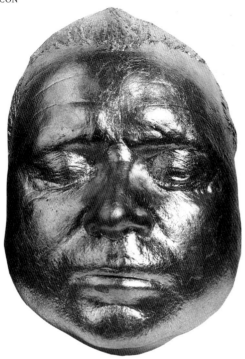

FRANCIS BACON, Clive Barker, 1969

Two powerful relationships marked this period of Bacon's long life and helped shift his artistic focus towards portraiture of people close to him. First, there was the relatively affluent amateur pianist Peter Lacy, who in frequent rages would knife those canvases that had escaped the artist's own destructive self-scorn. Then later came the small-time criminal and East End charmer George Dyer (1934–71). But it was as if there was a jinx attached to Bacon's success. In 1962, at the opening of the landmark retrospective of Bacon's work at the Tate Gallery, he received a telegram informing him of Lacy's death, and on the eve of the 1971 Paris retrospective at the Grand Palais (opened by President Georges Pompidou) George Dyer committed suicide in their hotel bedroom.

George Dyer (1934–71)

In all probability George Dyer would have stayed anonymous to all but a select band of the minor criminal fraternity and peripheral Soho drinkers, had he not walked up to Francis Bacon and John Deakin in a pub one day in about 1964, with the opening gambit, 'You all seem to be having a good time. Can I buy you a drink?' At least that is how Bacon remembered the first encounter with the man who was probably the

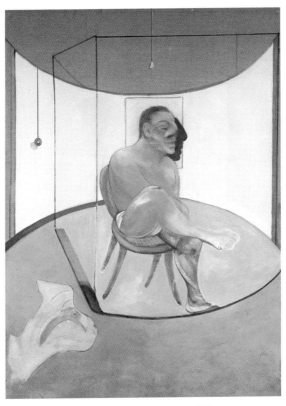

Study for Portrait [George Dyer], Francis Bacon, 1978

great love of his life and certainly an obsessive figure in his work, both before and after Dyer's death. Other painters, including Lucian Freud, found Dyer arresting enough to ask him to sit for them. Dyer was immensely proud of being the model for paintings which became so well known, and carried around photographs of some of them. In Bacon's *Study for Portrait*, which is clearly based on a photograph of George Dyer taken by John Deakin in the artist's studio, Dyer's physicality is exaggerated, almost idolised.

He was, however, totally ignorant of art, wherein lay part of his charm. Thickening his cockney accent, he would feign amazement at the high prices his lover's work was starting to fetch, declaring, 'All that money, an' I fink they're reely 'orrible!'

Francis Bacon was attracted to Dyer by his looks as much as his tales of time spent in prison, but both were deceptive. Far from being rugged, rough and self-contained, as Bacon would have liked, Dyer was actually very vulnerable. Kept financially afloat by Bacon, he drank himself daily into a stupor with a bunch of cronies, would have weeping fits and several times threatened suicide.

When Bacon tried to break Dyer's dependency on him by arguing that they should see each other less often, Dyer took desperate revenge by hiding some cannabis in Bacon's studio and then tipping off the police that they would find drugs there. Bacon was acquitted and declared to the Press as he left court that he bore no animosity to Dyer and would continue to employ him as a handyman.

At times, Dyer displayed an endearing scattiness. Dan Farson was at his parents' house in Devon one day when George turned up in a car with a group of friends. On a whim, they had piled out of the Apollo Club in Soho and driven off in search of the sea. 'Blimey,' said George, blinking at Dan, 'I fought we was going to Brighton.'

LUCIAN FREUD (born 1922)

An intensely private person, Lucian Freud hates being interviewed. 'I would like to be anonymous, in the most potential way,' he once told the *Observer*'s art critic William Feaver, who is one of the few people in the profession to have got anywhere near him. An artist's feelings, intentions and methods are, he has said, about as relevant as 'the grunts that tennis players emit when making their shots'.

Yet the man and the life cannot be separated, as so much of his work is autobiographical; its themes are his friends and his surroundings, sometimes even himself. The titles of his work may be anonymous, but the subjects are instantly recognisable as his two wives Kitty (daughter of the sculptor Jacob Epstein) and Caroline (Blackwood), or friends like Francis Bacon, Bacon's boyfriend George Dyer and Jeffrey Bernard's photographer brother Bruce.

Freud's grandfather, the psychoanalyst Sigmund, famously wrote that 'it's just the people with serious congenital defects of vision who become painters'. Undeterred, the young Lucian, who was born in Berlin but escaped to England with his family before the war, turned to painting. Some of the early work was distinctly Surrealist (a term he abhors), zebra-heads figuring prominently, but by the time he began seriously to frequent Soho, portraiture had become his forte. Now he is considered by some to be the most important figurative artist alive.

As a young man he became a great gambler. Like his best friend Francis

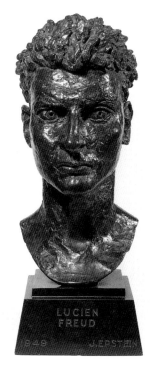

LUCIAN FREUD
Sir Jacob Epstein, 1949

23

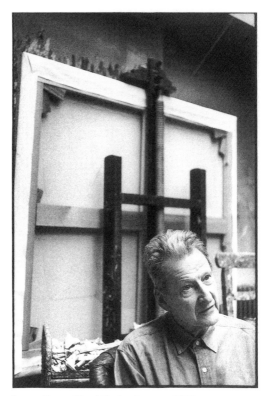

LUCIAN FREUD, Henri Cartier-Bresson, 1997

Bacon, Freud also mixed in high society. But, unlike Bacon, he has not shunned all awards, being proud of the Order of Merit bestowed upon him by the Queen. In later years, though, his subject-matter has been anything but grand. One favourite model was the overweight, gay performance artist Leigh Bowery, whose huge form spills over crumpled bed sheets – a now classic and instantly recognisable Freud background. Classic, too, is the palette of mud browns and of pinks, ochre and beige.

Freud's self-portraits are intense, unflattering, analytical, almost cold. This is a serious man, serious about his work. His concentration and the hours he puts in are phenomenal; he will often work all night. Part of the

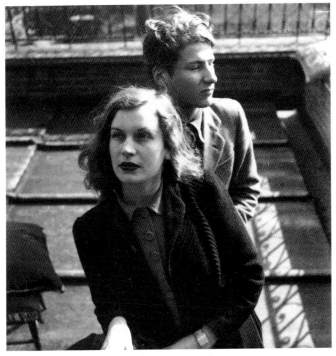

LORENZA HARRIS AND LUCIAN FREUD, Francis Goodman

attraction of Soho, when he was a regular there, was that it was possible to drop in and then drop out again. Only a very few close friends ever knew where he lived once he had moved to West London. In the eyes of the world, he became a recluse, while acquiring countless accolades, including the critic Herbert Read's rather ambiguous tribute that Freud is 'the Ingres of Existentialism'.

Cartier-Bresson's photo-study shows an artist who is both beguiling and defensive, the canvas behind him hidden like Freud's inner self. A carefully constructed impenetrability both warns and intrigues. Yet, as Jacob Epstein's sculpture emphasises, there could be great dignity in Freud's pose, as well as intensity.

LADY CAROLINE BLACKWOOD (1931–96)

When the eighteen-year-old Lady Caroline Blackwood 'came out' as a debutante in 1949, at a ball at Londonderry House, she was hailed as one of the great beauties of the season. She had long golden hair, big blue eyes and a fresh, healthy complexion that owed much to her privileged childhood on large estates in Ireland. Her father was the 4th Marquess of Dufferin and Ava, her mother was a Guinness. It was little wonder that Caroline found herself the new darling of London society hostesses, including Ann, wife of the author Ian Fleming.

It was Ann Fleming who introduced Caroline to Lucian Freud, and she reported that she was soon being ticked off for 'encouraging bizarre tartan-trousered eccentric artists to pursue virginal Marchioness's daughters.' Caroline needed little pursuing, in this case, as she eloped with Freud to Paris in 1952, marrying him the following year. From that twelve-month period date many of the most striking images of her, both photographs and Freud's oils, notably *Girl in Bed* (Private Collection). As well as highlighting Caroline's large eyes, which so captivated Freud, the canvas and the Getty photograph both convey a sense of the contradictions in her nature, of vulnerability mixed with defiance.

The Freuds took a Georgian house in Dean Street, and became regulars at the Colony Room and other artistic hangouts in Soho. But Caroline said that she knew from the beginning that Lucian was not a man to have children by; theirs was more of a prolonged love affair, made respectable by matrimony. The partnership could not last. Sure enough, by the end of the decade, they had parted and divorced – enabling Caroline to marry a very different character: the charming and even more eccentric American Jewish composer Israel Citkowitz.

The Citkowitzes lived in the United States and had three daughters. It was in California that Caroline first began to write, initially journalism on such topical subjects as the beatniks. By now, though, she was drinking and smoking heavily, and her second marriage also broke down. Israel devotedly followed her to London because of the children, and kept contact even when she married for a third time in 1972, to the disturbed and disturbing American poet Robert Lowell.

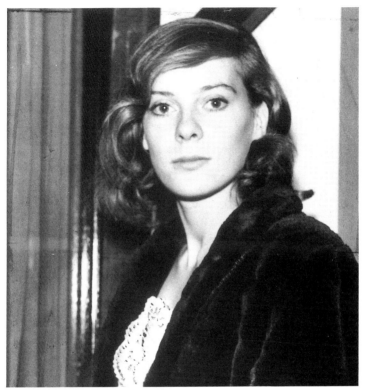

LADY CAROLINE BLACKWOOD, unknown photographer, 1953 (detail)

It was during the early years of her marriage to Lowell that Caroline came into her own as a writer of novellas and short stories. The best had a bleak, quirky, melancholy power, spiced with moments of sheer wickedness. However, her output declined, as she steeped herself in vodka and aggravated cancer by her smoking. There is an unsettling aggressiveness in her later non-fiction books, on subjects such as hunting and the Greenham Common peace women, which alienated some of her family and friends.

HENRIETTA MORAES (1931–99)

Audrey Wendy Abbot's baptism into Soho life took place at Humphrey Lyttleton's jazz club at 100 Oxford Street in 1950. She felt in tune with the mood, adopted the name Henrietta, and became a favourite among several up-and-coming artists because of her lack of inhibition.

At first working as a secretary, Henrietta soon realised this was not what she was cut out for, so she phoned round a few art schools to see if they needed life models, and began a career that brought her into contact with many of the rising new post-war artists, among them Lucian Freud and Francis Bacon. Henrietta's Rubens-style figure gave her an opulent voluptuousness much appreciated by many painters, although Bacon's typically distorted triptych of her concentrates on the anguished emotions of her face. She thought it made her look like a gypsy.

Henrietta set out to seduce Lucian Freud. Then she married the film director Michael Law. For a while, they had a Queen Anne house in Dean Street, right opposite an African gambling club called the Lagos Lagoon. Henrietta became a feature of the local scene, visiting the Gargoyle Club night after night, partying with Bacon, Freud, John Minton, Robert

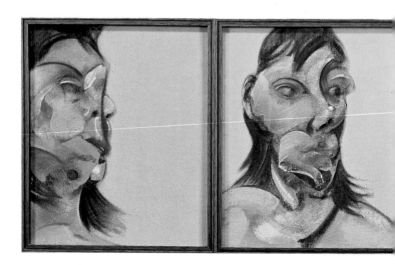

HENRIETTA MORAES, Francis Bacon, 1969

Colquhoun (1914–62) and Robert MacBryde (1913–66), and writers Claud Cockburn and Angus Wilson (see p.30). At first, she says, she felt like a mesmerised rabbit and was often reduced to tears by the *de rigueur* rudeness and bitchery of the Soho scene. Later, she got used to it.

Francis Bacon liked to work from photographs, so he commissioned John Deakin to take a series of shots of Henrietta lying nude on a bed. She expressed surprise when Deakin positioned his camera pointing between her legs, and sure enough, Bacon requested a second shoot, with different poses. Henrietta was not in the least amused to discover Deakin subsequently doing the rounds of the Soho pubs, selling prints of the first shoot to sailors at ten shillings a time.

In the late 1950s the marriage to Law collapsed, enabling Henrietta to marry John Minton's boyfriend Norman Bowler. Her third marriage, in the early 1960s, was to the young Indian poet Dom Moraes, introduced to her by David Archer. Although that marriage was also a failure, she kept the name Henrietta Moraes – so much more artistically satisfying than the one she was born with.

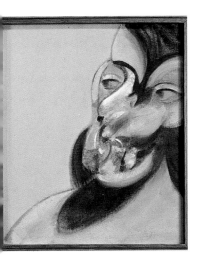

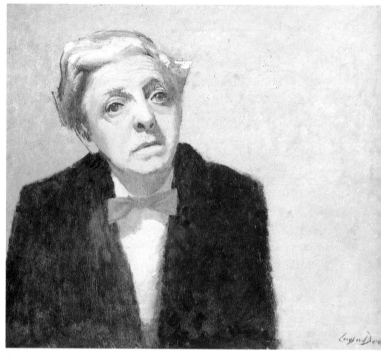

SIR ANGUS WILSON, Ann Langford Dent, *c*.1952

Henrietta was an extremely emotional person, much caught up in the soul-searching of the 1960s. She drank heavily, and suffered, then switched to drugs, and suffered. She became a hippie and took to the road in a gypsy caravan, mostly in the company of wealthy younger companions, who sang and smoked and had flowers in their hair, and some of her happiest times were spent in Ireland. But she finally settled tranquilly in a little room in Chelsea, with her dog Max.

JOHN MINTON (1917–57)

The painter John Minton had both the fortune and the misfortune to inherit rather a large sum of money from his maternal grandmother. This meant that he had the ability to be extremely generous, but it poisoned some of the relationships he tried to build. Ever ready to give, he found it almost impossible to receive. Then he would turn maudlin and complain 'I'm only liked because I'm rich,' adding spitefully, 'but I can buy anyone I want.'

Minton had developed a taste for sailors during the wartime blackout, and if there was a riotous band of uniformed *matelots* enjoying themselves

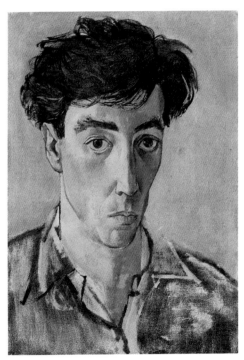

JOHN MINTON, Self-Portrait, *c.*1953

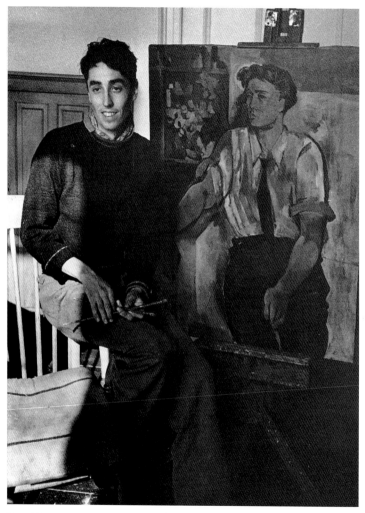

JOHN MINTON, Felix H. Man, 1949

at the Gargoyle Club, in Meard Street, John Minton would be in the middle of them. Unlike many homosexuals of his generation, however, Minton did not only fall for uneducated working-class men, sometimes he became infatuated with his students at the Royal College of Art. Worse, he became enamoured of the painter Robert Colquhoun, after Colquhoun and his lover Robert MacBryde had moved in with him, causing fearful scenes of tears and jealousy. That situation was resolved when the two Roberts moved out to the country, to live with George Barker (1913–91) and his partner, the novelist Elizabeth Smart, instead.

Even more painful was the triangular relationship John Minton established with a handsome young body-builder, Norman Bowler, and the artist's model and arch-bohemian Henrietta Moraes (as she later became). For a while, they lived happily together, until Minton foolishly asked Norman to choose between them. Henrietta records that her heart sank, as she knew Norman would opt for her, and harmony would be shattered. Nevertheless, Minton left her his valuable house off Cheyne Walk, Chelsea, when he died.

There was a strong streak of self-loathing in Minton's make-up. Some of that comes across in his self-portraits. He was skinny and gangly, although he could exercise great charm when he was in the mood. He worked extremely hard, eagerly accepting all the commissions that came his way, including countless designs for book jackets and other hack jobs. But as he matured, his painting deteriorated, providing a cause for grievance against friends such as Francis Bacon and Lucian Freud, whose reputations, in contrast, were soaring. The relationship between Bacon and Minton, already quite tense, was not helped when one day Bacon poured a whole bottle of champagne over Minton's head, declaring, 'Champagne for my real friends, real pain for my sham friends'.

Minton's self-portrait betrays an inner anguish that was often masked by his manic public behaviour. Some other artists, like Lucian Freud, apprehended the growing despair that led to his eventual suicide. His increasingly outrageous behaviour, such as driving round Piccadilly Circus in a taxi screeching 'I'm the Queen of England, but I can't remember which', had in fact been a shout for help, yet many friends were astonished when he took his own life with an overdose of pills.

GEORGE BARKER (1913–91)

When the nineteen-year-old George Barker came to London, one of his first ports of call was David Archer's bookshop, then just off Red Lion Square. There Barker met the young – and at that time still slim – Dylan Thomas, pipping him at the post by having his own first book of verse published by Archer in 1933. 'If women and drink have saved many poets from madness and death,' Barker recalled later in a volume of memoirs, 'here, in Parton Street, politics and poetry saved many of us from women and drink.'

Not for long. By the time all the principal protagonists had moved on to Soho, George Barker was a bohemian with a vengeance. T. S. Eliot, who had been rather taken with the young man's early verses, exercised his editorial right at Faber and Faber to cut one long sequence called 'The True Confession of George Barker' from his *Collected Poems, 1930–1955*, on the grounds that it was a hymn to copulation. In real life, procreation ranked alongside prosody in Barker's list of priorities, which perhaps explains why he did not resemble most people's idea of a poet. In John Deakin's characteristically unflattering portrait, Barker looks more like a somewhat disreputable travelling salesman.

His poetic style was not appreciated by all. He never grew out of a juvenile enthusiasm for puns. Some critics winced at his rhyming 'Apocalypse' with 'umpteen tits'. Others, like the poet Robert Nye, doffed their hat to a 'hit-and-miss man, a wild artist if ever there was one, a verbal spendthrift throwing his talents down in poem after poem from the precipice of self to commit suicide on some rude and rugged pun'.

Barker stayed true to his poetic vision, which meant he fell out of fashion. It was galling for him at one time to be known mainly as Elizabeth Smart's partner. But his survivors, including progeny from various unions, such as Smart's son, the poet Sebastian Barker, continued to fight his corner. On the day of George Barker's death a stinging review of his work by Professor John Carey appeared in the *Sunday Times*. Subsequently, there was a contretemps at the Reform Club, when Barker's widow Elspeth ran into Carey. But when she was questioned about this by the Press, she dismissed the episode in a way that George would have savoured, stating witheringly that 'nothing but the utmost civility passed between myself and that creep'.

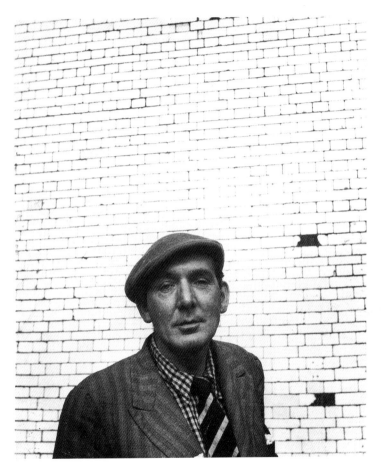

GEORGE BARKER, John Deakin, c.1952

JOHN DEAKIN (1912–72)

George Melly summed up John Deakin succinctly, as 'a vicious little drunk of such inventive malice and implacable bitchiness that it's surprising he didn't choke on his own venom'. Many Soho regulars were masters of the catty remark, using it as a heavy-handed form of wit, while knowing that they would soon be at the receiving end of similar

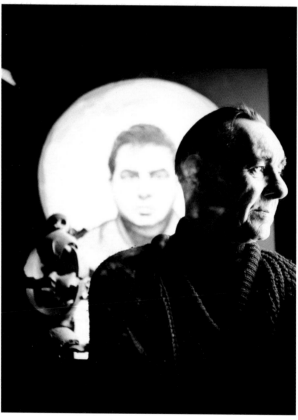

treatment. Deakin was different, he really enjoyed hurting people, not least his long-suffering partner David Archer, and he savoured their misfortunes. His saving grace, though, was his photographic genius. Until the National Portrait Gallery retrospective in 1996, he had never really been given his public due. But John Deakin was one of the most original and authoritative photographic voices in post-war Britain.

Part of the neglect was self-inflicted. Deakin took little care of his prints, and less of his negatives, stuffing them into drawers or under his bed, which meant that a high percentage of them got ripped, creased or stained. He also alienated employers, clients and others who could have helped him. He was sacked from *Vogue* not once but twice, and they did not take him back a third time.

During his time at *Vogue* in the 1940s and early 1950s, Deakin not only produced hundreds of often highly original fashion plates, he also took portraits of artists and writers, including Francis Bacon, Lucian Freud, George Barker and Elizabeth Smart. Later, as a free agent, he took many more, cataloguing virtually the entire cast of Soho in the 1950s and 1960s. This was done for no ulterior motive, but as an expression of his fascination for faces, which he portrayed with startling candour, in stark contrast to the work of *Vogue* contemporaries such as Cecil Beaton. As Colin MacInnes correctly recognised, 'many of those who, all unwittingly, were [Deakin's] sitters, are crushed by life; and the artist, quite without condescension or sentimentality, sees the poignancy of their desperate will to live in a world that has quite defeated them'.

John Deakin professed to have a total contempt for creativity, once shouting across to Robert Colquhoun and George Barker, 'Art crap, Poetry crap!' Few realised that in his youth he had himself been a painter, working in the South Pacific, thanks to the generous sponsorship of a wealthy patron. He travelled extensively at this gentleman's expense, before picking up an old camera in Paris one day in 1939 and discovering his true vocation.

Deakin upset many of his sitters by his total lack of social graces. When Noël Coward complained, Deakin retorted, characteristically, 'Tough shit'. He usually looked a mess as well, sporting a filthy sheepskin coat, although he could smarten himself if needs be, as for Luke Kelly's powerful photo-portrait of him, with the brighter light of Francis Bacon looming over his shoulder. The picture nicely captures the cruel Deakin lips, the barely suppressed sneer.

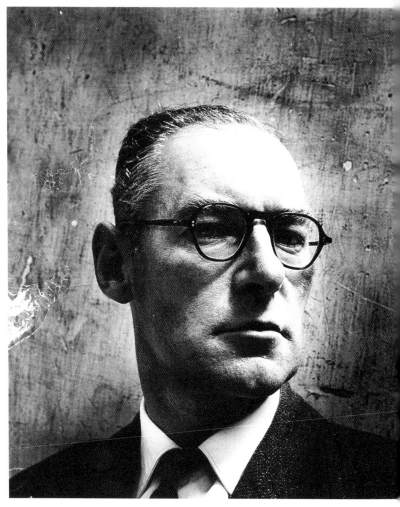

DAVID ARCHER, John Deakin, 1952

DAVID ARCHER (1907–71)

The great unsung hero of Soho, indeed of British literature for many years from the 1930s, David Archer, publisher, bookseller and promoter of new talent, sacrificed his own well-being for the good of others. As a bookseller he had a fatal flaw, in that he hated to part with any volume. Customers at his shop in Greek Street (and its earlier incarnation off Red Lion Square, Bloomsbury) often had a hard job persuading him that a book they wished to buy would be better off with them than on his shelves. Sometimes he would cling to a tome and inform them that he was sure they could find a copy somewhere else.

Archer created a literary salon in the shop, at which coffee and cheap but delicious rolls would be served. Henrietta Moraes was recruited to serve. George Barker, Colin MacInnes, Christopher Logue and other writers would drop by daily for a chat, without ever buying a book. The inevitable demise of the enterprise was accelerated by Archer's habit of raiding the till at lunchtime before heading off for the Coach and Horses or the French Pub.

Much of the money was handed out as subsidies to writers and artists he considered good causes. Sometimes it would be discreetly secreted in matchboxes, which he would then press on the bewildered recipient, who might throw the box away without realising what was inside. John Deakin exploited David Archer's generosity shamelessly, demanding money for drink or other 'necessities' whenever they ran across each other, then, as often as not, telling Archer to 'piss off'.

John Deakin's photograph makes Archer appear a rather drab, sexless character. Physically, David Archer resembled an inoffensive and ineffective suburban bank manager, dressed in a rather dowdy suit. It was hard to believe that this was the man who had spotted the early talents of Dylan Thomas and George Barker, and helped launch them on their literary careers. He was, however, temperamental and could literally scream with rage. Henrietta Moraes and Archer's business partner Ralph Abercrombie bought a lockable cash-box, to try to keep a check on disappearing funds; returning to the shop to fetch something one night, Henrietta found her boss purple in the face, jumping up and down on the cash-box in a vain attempt to break it open. Sheepishly he looked at her and said, 'Silly old me.'

MURIEL BELCHER (1908–79)

A foul-mouthed, butch bisexual of Portuguese Jewish origin, Muriel Belcher's genius was to create one of the most remarkable clubs in post-war Britain. The Colony Room, which she opened in December 1948, was spoken of by its regular patrons simply as 'Muriel's'. She presided over it like a hawk, perched on her stool near the door, ready to pounce on any newcomer or person who was currently in disfavour. Her put-downs were withering. 'Not a vision of loveliness tonight, is she?' she would pronounce, as some hapless man made his way to the bar. Fluent in *polari*, the underground homosexual slang popularised by the entertainer Kenneth Williams, Muriel called most men 'her'. Even the late German Führer was cut down to size by being referred to as 'Miss Hitler'.

Not surprisingly, some people took the insults badly. The novelist John Braine (author of *Room at the Top*) was so angry when Muriel declared 'There's plenty of room at *her* top' when he visited the club, that he consulted a lawyer, who wisely told him not to be silly. Others relished the wit. At its best, it was sharp and it was funny, puncturing pomposity and displaying a keen sense of the absurd. Muriel knew nothing about art and claimed not to read books, which is probably why so many successful artists and writers felt at ease with her, knowing they would be spared interrogation about their latest work in progress. On a good afternoon in the 1950s the painters Francis Bacon, Lucian Freud and Frank Auerbach might be found gathered in the Colony Room, while John Minton, in a world of his own, danced in a corner.

The image Muriel projects in photographs is part mother, part prison warden: stern, yet also indulgent towards her wayward charges. She always said the people she liked the best were the ones who spent the most, but in reality, Muriel often got richer clients unwittingly to subsidise impoverished favourites. She gave those who had money but were slow at spending it short shrift. 'Open your bead-bag, Lottie,' she would bellow. Time was announced with a cheery 'Back to your lovely cottages!'

Dan Farson recounts a story that somehow encapsulates Muriel, who late one night saw two pairs of little red eyes staring at her from the floor – rats which had presumably come up from the grubby restaurant downstairs. 'You two can fuck off', she snarled. Then, softening her tone, she added, 'You see, I've called last orders. Anyhow, you're not members.'

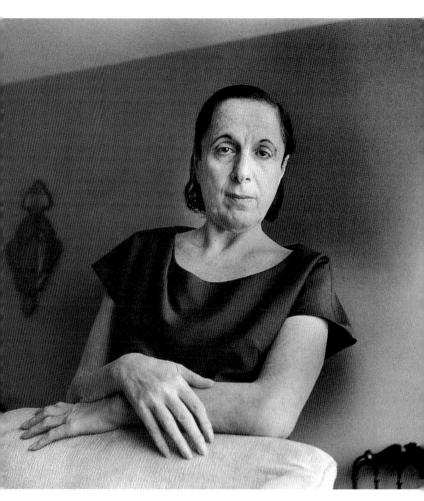

MURIEL BELCHER, John Deakin, 1960s

ROBERT COLQUHOUN (1914–62) AND ROBERT MACBRYDE (1913–66)

❦

The two Roberts came to London in 1941, as Scottish as could be, dressed in kilts and ready to take on any man who passed sly comments about Jocks. They had met at school in Kilmarnock. Both studied at the Glasgow School of Art and both were awarded a travelling scholarship to the Continent. By then, they were a partnership and were recognised as such.

Not that they were particularly alike. MacBryde was much darker, almost Mediterranean-looking; he was the more passionate of the two, playing the more feminine role in their ménage, shopping and cooking and doing all he could to ensure that Colquhoun – to whose artistic superiority MacBryde deferred – could work in peace. Once, MacBryde was seen ironing his partner's trousers with a heated teaspoon.

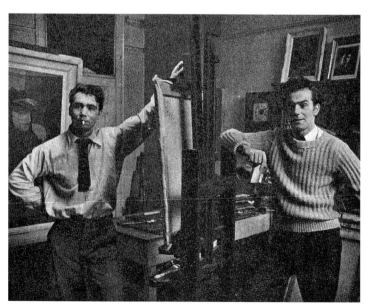

LEFT TO RIGHT: ROBERT MACBRYDE AND ROBERT COLQUHOUN, Felix H. Man, 1949

The Roberts were fortunate in finding Peter Watson, a very rich patron of the arts, almost as soon as they came to London, and he helped guarantee their early success in the capital. But others were not slow in coming forward to help them either. There was something endearing about them, despite their frequent quarrels, which on at least one occasion resulted in their fighting each other right across a Soho bar, out through the door and into the street. Colquhoun, in particular, was prone to sudden fits of violence, which could be directed at total strangers. Several photographers took series of joint portraits of them, either in their studio or relaxing at home; Felix Man's photograph of them painting together emphasises the mutually supportive aspect of their working relationship – although that was not nearly so balanced as the image suggests.

Nonetheless, John Minton was, for a while, enchanted. For their part, the two Scotsmen, proud of their working-class origins, had little time for Minton's circle of middle- and upper-class friends, or for his pursuit of respectable commissions. Colquhoun grew tired of Minton's affection, but he was wary of most displays of emotion. When MacBryde would be discoursing proudly on Colquhoun's work in a Soho bar, Colquhoun would glower over his whisky glass.

Lucian Freud was fascinated by Robert Colquhoun, recalling that 'He seemed very doomed and had a certain grandeur. He saw how tragic his situation was and also that it was irreversible.' Colquhoun's earlier artistic promise did not seem likely to be fulfilled, and he became an increasingly menacing presence. In 1958, though, an apparent big break occurred, when the Whitechapel Gallery in the East End offered Colquhoun a retrospective, to which he was asked also to contribute some new works. He locked himself away and worked furiously. But before the exhibition opened, thieves broke in, damaging or destroying all the canvases, crushing his will in the process. Neither his creative energy nor his reputation fully recovered.

Brendan Behan (1923–64)

❧

Soho and neighbouring Fitzrovia reverberated to the short but impressive sojourns there of the playwright Brendan Behan. The British Press, unimaginatively, dubbed him an Irish Dylan Thomas, and like that diminutive Welshman, Brendan certainly had the gift of the gab. His literary work may not have reached the height of Dylan's best, but as an entertainer and a fabulist, Brendan could have beaten Dylan hands down. He was larger than life, in fact, at sixteen stone, distinctly fat, slovenly looking and volcanic. Perhaps as a result of his Dublin pub background, he was adept at becoming bosom friends with complete strangers, including servicemen.

He had interesting songs to perform. He exaggerated his slum background, but he had indeed got involved with the IRA at an early age, and had spent time in Borstal, discovering that brutality exists even in Suffolk. In fact he was barred from mainland Britain in 1939, although he returned in triumph in 1956, when Joan Littlewood, the director and impresario put on his play *The Quare Fellow* at Stratford East, to huge acclaim. Later, the play transferred to the Comedy Theatre in the West End. In New York, that would have been enough to give Behan immense cachet. In the cynical surroundings of Soho, he had to earn his stars by being entertaining – a test he easily passed. In particular, Brendan loved to send up journalists. He would gleefully recount that he wore green ties for his country, red ties for his school, and blue ties when he had a hangover – which was why he was only ever seen in a blue one. All this was dutifully reported, although in fact he hardly ever wore a tie at all.

Brendan Behan's playful antipathy to the Press did not stop him working closely with Dan Farson, who took several series of photographs of him, both in Dublin and London, providing us with lasting images of an overgrown schoolboy, irrepressible, slightly disgusting, but also great fun. David Low's sketch gives intimations of a certain innocence in Behan's character; the little-boy-lost, who compensated for insecurity with cockiness that could all too easily boil over into aggression.

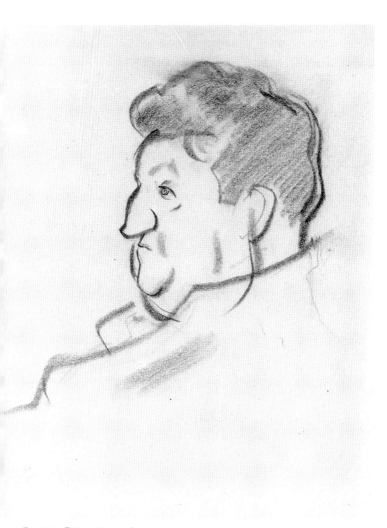

BRENDAN BEHAN, Sir David Low

GASTON BERLEMONT (born 1914)

❧

When they first arrived in London from France in 1900, Gaston Berlemont's parents lived in a cramped room in Covent Garden. Victor, his father, worked as a waiter in a number of restaurants, including the European in Dean Street, next door to the Wine House, as the York Minster was then called, and shortly before the outbreak of the Great War the Berlemonts acquired the pub. Gaston was born upstairs, thus being born-and-bred Soho, although his customers tended to think of *him* as the foreigner. Gaston did nothing to undermine this image, cultivating a large gallic moustache just like his father's and keeping the pub's atmosphere distinct from that of the English competition all around. Attractive ladies would be greeted with an elegantly executed kiss on the hand, and even streetwalkers were dealt with by him courteously when they came in for a drink – strictly off-duty, of course.

GASTON BERLEMONT, Joëlle Dépont, 1989

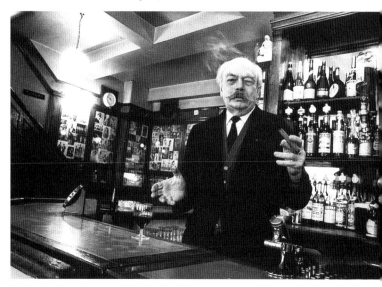

During the Second World War, the York Minster became a rallying point for the Free French, hence its nickname the French Pub, and for years on Bastille Day, Gaston would hand out *tricolore* rosettes. In contrast to most London pubs, which viewed wine with disdain, serving the most dreadful plonk, if at all, Gaston imported his own fine selection.

Dan Farson has left the most vivid picture of Gaston Berlemont in his working environment, in his book *Soho in the Fifties*. Having been steered out of the door of the French Pub at closing time on numerous occasions, Farson acknowledges the diplomatic finesse with which Gaston despatched drunks: 'One of the two of us will have to go,' he would say, 'and I'm afraid it's not going to be me.' The geniality and the firmness are both there in Joëlle Dépont's photo-portrait for a *Sunday Times* profile. Fittingly, Gaston is shown in his working environment. Unlike some of his Soho colleagues, however, he knew when he needed to call time in his own working life – moving out to Hendon to enjoy his years of retirement.

Gaston was generous in providing small loans to some of his regulars, though he was enough of a businessman not to extend unsecured credit. The ageing Nina Hamnett, a somewhat tiresome presence, had to beg for her drinks from other customers at the French. It was there one afternoon, under Gaston Berlemont's gaze, a typical Soho scene occurred. For the umpteenth time, Nina Hamnett whined for a donation from a harassed David Archer, who responded despairingly, 'Oh, not again, Nina. No,' before taking his leave. But he was back again within the half hour, his face flushed with embarrassment, presenting her not only with a ten shilling note, but also a large bunch of flowers.

COLIN MACINNES (1914–76)

❦

Even by the difficult standards of Soho, Colin MacInnes was not an easy man; as Dan Farson noted, he would push the door of the Colony Room open abruptly, as if it had done him an injustice. However, Muriel Belcher would brighten when he entered. She liked tension, which he was almost guaranteed to supply, often in the form of ordering his latest paramour around like a cabin boy. On other occasions, he turned his bile on any convenient target. Soon after meeting MacInnes for the first time, Farson ran into him again and bounded up eagerly, only to be rebuffed with a glare and the put-down, 'Look, Mister, just because we've met doesn't mean you're allowed to talk to me.'

Colin could be cruel, wounding and provocative, and like many such people, only really respected those who were able to answer back. But he was also perceptive and analytical and he captured in his writing some of the spirit of the age. Even those who loathed him as an individual had to admire the power and the prophecy of novels such as *City of Spades* (1957) and *Absolute Beginners* (1959), and much of his occasional journalism was first-rate.

As MacInnes's biographer Tony Gould has pointed out, Colin's discovery of his homosexuality and his drinking developed simultaneously, both guaranteed to scandalise members of his eminently respectable family (through his mother, the author Angela Thirkell, he was related to Stanley Baldwin, Edward Burne-Jones and Rudyard Kipling). He set out to get to know Afro-Caribbean London, which in those days was centred on Soho, the Tottenham Court Road and the gambling dens of Cable Street. Enamoured of virtually the entire troupe of a visiting black dance company, he referred to them as his 'dark angels', inviting much derision and hostility from some of his white friends.

The 1950s were a difficult period for homosexuals, particularly those with a preference for partners of a different race. It was not just that sex between 'consenting males' was illegal (and was to remain so until 1967) but there were continuing police crackdowns on known gay men. Colin MacInnes did not shy away from the ensuing debate, but he irritated some of his homosexual acquaintances by championing the cause of bisexuality.

With his canny eye, John Deakin captured some of MacInnes's cruelty.

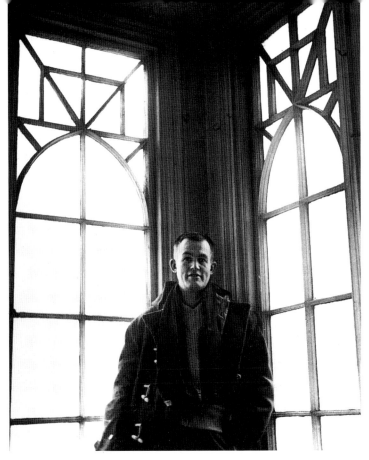

COLIN MacInnes, John Deakin, mid 1960s

Colin's icy look made some people mistakenly believe he was a plain-clothes policeman, whereas it was sometimes he who was confronted by the Law. His misanthropy expressed itself in petty forms – not turning up for an appointment, or patently showing his boredom in conversations. Yet occasionally he would make amends by writing to people to apologise for his bad behaviour.

DANIEL FARSON (1927–97)

A significant chronicler of Soho life, both in words and images, Dan Farson was the son of the celebrated and dashing foreign correspondent Negley Farson. Dan differed from most Soho *habitués*, who were passionately devoted to one calling, or to none. He was a jack of many trades: photographer, journalist, art critic, television presenter and even pub landlord. Business was never Dan's greatest strength.

DANIEL FARSON, John Deakin

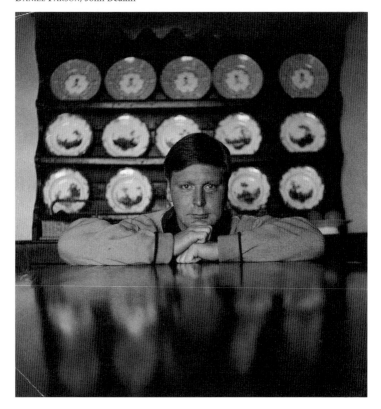

He lived in the East End for a while, in Narrow Street, Limehouse, where Francis Bacon followed him. It did not take Bacon long to discover that however thrilling the proximity of East End youths might be, the light was all wrong and the boats on the Thames were too noisy.

Rather as Christopher Isherwood portrayed himself as a sexless wimp in his Berlin novels, so as not to distract attention from the other characters, so in much of his writing on Soho, Dan played down his own, highly participatory role. Characters as demanding as Bacon would never have tolerated his companionship for so long had he merely been a note-taking acolyte. Dan could match anyone when it came to living life to the full, becoming livelier (and at times more belligerent) as the drinking day went on. He could give as good as he got when it came to tart remarks, and produce his own quota of surprises.

One of those surprises was his becoming a television celebrity in the early 1960s, at a time when television interviews of the famous were still in their infancy, and for a while he presented a live television programme called *This Week*, during which his name was made with a memorable interview with Dylan Thomas's widow Caitlin. It was John Deakin who suggested Caitlin as a subject, and when John arrived at the studios with her, it was clear that they were both quite drunk. The conversation naturally focused on Dylan's last days, and in particular, the recent publication of a controversial book by an American, John Malcolm Brinnin, *Dylan Thomas in America*. Caitlin squirmed in her seat and exclaimed: 'Oh, the bloody man was in love with my husband!', at which point, on a signal agreed by Dan and his producers, the plug was pulled. It caused a press sensation.

Yet it is likely that of all Dan Farson's many roles, it is as a photographer that he will be best remembered. He recalled being shaken by the brutality and originality of photographs that John Deakin showed him. Perhaps those gave him the courage to develop his own distinctive style, and his work includes countless portraits of Soho and Fitzrovia figures. Not just the famous ones, but also, like Deakin, the anonymous, whose faces linger in the mind, like the sailors having a good night out in the Fitzroy Tavern, or beggars in a Barcelona street, captured with brilliance and poignancy. Deakin's own portrait of Dan, seated thoughtfully in front of a Welsh dresser displaying china, shows a man who was as much an observer as someone being observed, staring determinedly straight ahead, yet displaying a slight touch of panic.

RONNIE SCOTT (1927–96)

❦

Born Ronald Schatt (a name he ditched early on), Ronnie Scott was a smart-talking East End Jew whom Fate predestined to be a jazz musician. His father Jock, who took the professional name Scott, was divorced by Ronnie's mother when the boy was four, reappearing years later to offer his son a job in a band which he himself led. Ronnie's step-father was at least as formative, however; he bought the boy his first instrument, a cornet, and gave him a £1,000 loan to start his first club.

Modern jazz in Britain was launched in Soho, notably at the Club Eleven in Great Windmill Street, which later moved to Carnaby Street. Ronnie was in on Club Eleven from the beginning and was amongst those arrested there in a drugs raid. In time-honoured fashion, the magistrate in court asked, 'And just what is be-bop?', to be informed confidently by a police witness that it was 'A queer form of modern dancing; a negro jive'.

Scott's own jazz club opened in Gerrard Street in 1959, moving to its more familiar – and subsequently larger – premises in Frith Street six years later. A whole parade of famous British and American musicians and singers appeared there, including Zoot Sims, Stan Getz, Miles Davis, Johnny Dankworth, Ella Fitzgerald and Sarah Vaughan. On some nights, the audience was as celebrity-studded as the stage, Peter Sellers, Spike Milligan and Princess Margaret all having a penchant for the place.

But midweek the club could sometimes be deserted, which was a source of some of Ronnie's large but frequently recycled fund of dreadful puns and cringe-making jokes. 'Someone phoned this evening and said "What time do you open?" "What time can you get here?" I replied.' Audiences who failed to react to the music were chided from the stage for being corpses, while those who chattered too much were peremptorily told to shut up and pay attention. Even the Club's menu was not immune. 'Food untouched by human hand,' it proclaimed, 'Our chef is a gorilla.' Or: 'Now featuring a tremendous step towards inter-racial relations: ham bagels.'

Scott had a nice dead-pan delivery, and often put on a hang-dog expression. He was self-deprecating, even when it came to the club he adored: 'I love this club. It's just like home: filthy, and full of strangers.' Yet he could be quite suave and dapper when he tried. It was unwise to

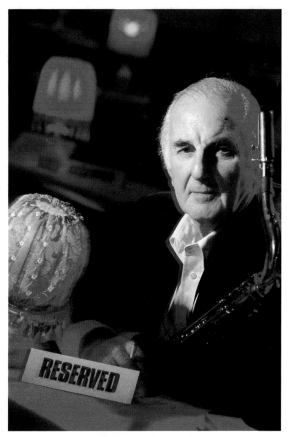

RONNIE SCOTT, Philip Sayer, 1991

try to rouse him early, however. Unlike most of his performers and his clientele, Ronnie Scott did not drink, but he was nevertheless a creature of the night. As he told the musician and journalist Benny Green one day, he could not begin to distinguish shapes until after two in the afternoon.

In Philip Sayer's photograph Scott almost seems to be touting for customers. There is an edge to his expression, as if he is daring one to call him a failure – a verdict only he himself could deliver, knowing it to be untrue.

GEORGE MELLY (born 1926)

☙

The jazz singer, critic, art-collector, cartoonist, comic and compulsive autobiographer George Melly is a showman, on and off-stage, instantly recognisable by his loud suits, fedora hat and flamboyant ties. The son of a very liberal but solidly middle-class Liverpudlian family, George early decided to add spice to his life. He spent a boisterous period in the navy at the end of the war (recounted with gusto in his book *Rum, Bum and Concertina*, 1977) and arrived in London with twin passions for jazz and handsome young men. Nevertheless, he has had a long and candidly open marriage to his wife Diana.

Diana was a hippie during the 1960s, and George himself got arrested at a Ban the Bomb march – ending up sharing a police cell with Vanessa Redgrave. Many fellow Sohoites looked askance at such radical political action, but George could always reassure them by joining in their sexually ambiguous banter, and sharing some of their louche perspectives on life.

Melly claims he became a singer because he was too lazy to learn an instrument, but his gravelly voice and accompanying patter quickly established him, and he became an annual fixture at Ronnie Scott's. He has also been ubiquitous at art galleries around London's West End, sometimes as critic, sometimes as collector. Every available square inch of the walls in his houses in West London and in Wales seems to be covered in canvases, many of them Surrealist or naïve works, picked up for a song.

The comfort of his domestic surroundings is in stark contrast to the squalor he professes to love, and which partly drove him to Soho. But then George Melly is a man with two contrasting sides: a clown who has a far more serious inner self. He gave up being film critic for the *Observer* because he claimed he felt he was in danger of becoming respectable. But in truth, he is one of life's freelancers, ever on the lookout for new experiences and new roles.

He was much loved by a wide cross-section of Soho's characters, including the indomitable Muriel Belcher at the Colony Room, for if

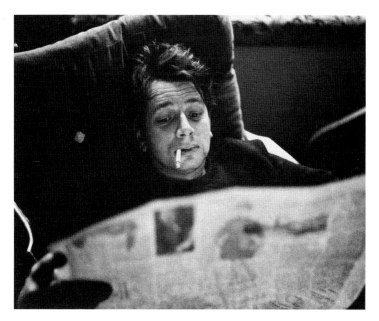

GEORGE MELLY, Lewis Morley, 1960s

anyone ever needed help, like a bed for the night, or a free act to help raise money at a charity gig, George Melly would be first to step forward. There is an impishness about the man that is nicely captured in Lewis Morley's photo-portrait – although, as with many clowns, Melly's jollity and flamboyance are a façade behind which sombre moods predominate.

JEFFREY BERNARD (1932–97)

It is hard to explain the appeal of Jeffrey Bernard. After all, he spent most of his life trying not to be liked. Some people, such as the novelist Francis King, could not see the point of him, but the whole point of Jeffrey Bernard was that there *was* no point. His existence, particularly its latter half, was an exercise in saloon-bar nihilism.

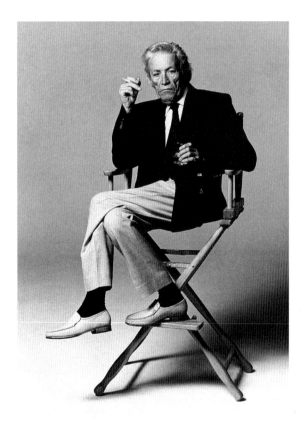

JEFFREY BERNARD, Trevor Leighton, 1990

This was quite different from the lofty, artistic/philosophic nihilism of Francis Bacon. Bernard himself accepted that it was a much lower form, but then lowness was a crucial element of Bernard's pose, as exemplified in his *Spectator* column 'Low Life', once described as 'a suicide note in weekly instalments'. The column was published in satisfying counterpoint to the preposterous 'High Life' column of the Greek millionaire socialite 'Taki'.

In his obituary of Jeff, Taki recalled accurately that 'he was dyspeptic, but almost always lightened the atmosphere with a flash of humour and the *de rigueur* four-letter word'. Bernard was foul-mouthed, but he survived because he made people laugh, and when he did not feel like surviving any more, his body disintegrating around him, one leg chopped off below the knee, he died.

By then, he was world-famous, largely thanks to the immensely successful play by Keith Waterhouse entitled *Jeffrey Bernard Is Unwell*; Peter O'Toole was the inspired casting for the role in the original production. In the play, Jeff was locked in the Greek Street pub, the Coach and Horses, overnight. In reality, by day, it was his workplace, as well as his stage. He clocked in as punctually at opening time as any factory worker, installing himself on his favourite bar-stool.

All the many photographs taken of Jeffrey Bernard in maturity, including this unsettling portrait of him by Trevor Leighton, smartly dressed and sitting cross-legged in a director's canvas chair, show a face ravaged by self-abuse. One doctor blithely informed his students, as they stood around Bernard's hospital bed, that his patient 'closes his veins each day with sixty cigarettes, and then opens them up again with a bottle of vodka'.

Yet as a youth, when Jeff first landed in Soho, he was strikingly attractive, finding little difficulty in being taken up by women and men alike. Francis Bacon and John Minton were both generous patrons (without ever getting paid back in kind), and a large number of women took him under their wing. He once informed the third of his four wives that he had slept with 250 women, to which she tartly replied that did not sound very many. Instantly rewriting his life-story, Bernard declared that actually the figure was 500.

RICHARD INGRAMS (born 1937)

❦

Considering Richard Ingrams spent half his professional life poking fun at the Establishment, puncturing pomposity and deflating bores, he struck many of his fellow Soho *habitués* as a trifle dour. Long before he reached middle age, he was shuffling around the area near the *Private Eye* office in Greek Street, clad in tired corduroys, scruffy shoes and shirts that looked as if they had never met an iron. Not so much a young fogy as a premature oldie, with attitudes to match, he is that rarest of Soho creatures, a puritan, somehow blending the more restrictive values of his parents' separate Anglican and Roman Catholic creeds, superficially concealed by a froth of schoolboy mirth.

Ingrams' prejudices are legion, though one had to be careful to distinguish what was the line being taken by Britain's most popular satirical magazine and the personal views of its editor. Both had an anti-gay slant; 'bent' vicars were an easy target from the moment the publication began. Even less politically correct was the *Eye*'s relentless pursuit of wayward Jews, yet even to this day, Ingrams gets upset if anyone suggests he is an anti-Semite; it just so happens that favourite villains were men such as the millionaire businessman Sir James 'Goldenballs' Goldsmith.

The son of a merchant banker, Richard Ingrams went to Shrewsbury School, as did Paul Foot, Willie Rushton and Christopher Booker, his collaborators on *Private Eye* – originally a few mimeographed sheets, but soon a publication printing in the tens of thousands. The moment, 1961, was opportune. Debunking was all the rage. Satire ruled. For a year Christopher Booker was in charge at *Private Eye*, before being ousted by Ingrams in a coup involving the simple expedient of a locked door, and for the next twenty-three years Ingrams occupied the editor's chair, presiding over the notorious weekly lunches, at which the next victims were chosen. Politicians were of course fair game. As the National Portrait Gallery's 1997 *Private Eye* exhibition reminded us, Harold Macmillan, Harold Wislon [sic] and Ted 'Grocer' Heath were all subjected to a concerted assault.

Lewis Morley's photograph shows Richard Ingrams photographed with Tony Rushton and rather incongruously two 'dolly-birds'. *Private Eye* may have been red-blooded but Ingrams has always maintained that one of the most quoted stories about him – that Germaine Greer, the

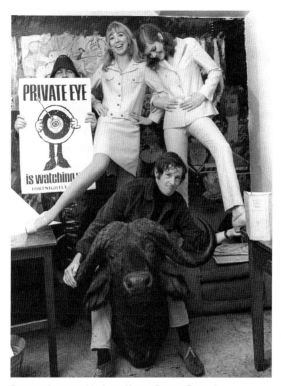

RICHARD INGRAMS (AT LEFT, HIDING BEHIND POSTER)
WITH TONY RUSHTON, Lewis Morley, 1966

feminist icon, once pursued him into a lavatory on a train, determined
to seduce him, but failed – is pure fabrication.

The Soho crowd read *Private Eye*, and sometimes appeared in it. One or
two secretly wrote for it, or phoned in anonymous tips. But it was never
quite accepted, until the later Groucho Club days, when Richard Ingrams
became one of the club's most devoted patrons.

List of Illustrations

❦

Map of Soho
© National Portrait Gallery

Francis Bacon, 1909–92
Bill Brandt, 1963
Bromide print, 32.3 x 27.8cm
Bill Brandt © Bill Brandt Archive Ltd
National Portrait Gallery (x9223)

Lucian Freud, born 1922 and Brendan
Behan, 1923–64
Daniel Farson, 1952
Glossy bromide print, 19.6 x 19.3cm
© Estate of Daniel Farson
National Portrait Gallery (x22187)

Dylan Thomas, 1914–53
Mervyn Levy, 1950
Pencil, 42.2 x 32.1cm
© National Portrait Gallery (4335)

Dylan Thomas, 1914–53
Rupert Shephard, 1940
Oil on canvas, 45.7 x 30.5cm
© Reserved
National Portrait Gallery (4284)

Dylan Thomas, 1914–53
John Gay, 1948
Bromide print, 29 x 22.4cm
© Estate of John Gay
National Portrait Gallery (x47303)

Nina Hamnett, 1890–1956
Daniel Farson, 1952
Bromide print, 17.5 x 17.4cm
© National Portrait Gallery (P288)

Nina Hamnett, 1890–1956
Roger Fry, 1917
Oil on canvas, 137.1 x 91.5cm
© University of Leeds

Francis Bacon, 1909–92
Reginald Gray, 1960
Oil on board, 45.1 x 37.1cm
© National Portrait Gallery (5135)

Francis Bacon, 1909–92
Clive Barker, 1969
Gilt bronze mask, 21.6cm (height)
© National Portrait Gallery (5844)

Study for Portrait [George Dyer], 1934–71
Francis Bacon, 1978
Oil on canvas, 198 x 147.5cm
© Estate of Francis Bacon/ARS, NY and
DACS, London 1999

Lucian Freud, born 1922
Sir Jacob Epstein, 1949
Bronze cast, 40cm (height)
© Estate of Sir Jacob Epstein
National Portrait Gallery (5199)

Lucian Freud, born 1922
Henri Cartier-Bresson, 1997
Bromide print, 35.7 x 24.2cm
© Henri Cartier-Bresson/Magnum Photos
National Portrait Gallery (P724)

Lorenza Harris and
Lucian Freud, born 1922
Francis Goodman
Modern print, 21.6 x 16.5cm
National Portrait Gallery (x87292)

Lady Caroline Blackwood, 1931–96
Unknown photographer, 1953
Copy print, 18 x 24cm (detail)
© Hulton Getty

Henrietta Moraes, 1931–99
Francis Bacon, 1969
Oil on canvas, 35.5 x 30.5cm
© Estate of Francis Bacon/ARS, NY and
DACS, London 1999

Sir Angus Wilson, 1913–91
Ann Langford Dent, c.1952
Oil on canvas, 50.8 x 61cm
© Ann Langford Dent.
All Rights Reserved
National Portrait Gallery (6349)

John Minton, 1917–57
Self-portrait, c.1953
Oil on canvas, 35.6 x 25.4cm
© Royal College of Art
National Portrait Gallery (4620)

John Minton, 1917–57
Felix H. Man, 1949
Glossy print, 24.9 x 18.3cm
© The Cheshire-Baumann Trust
National Portrait Gallery (x11803)

George Barker, 1913–91
John Deakin, c.1952
Bromide print, 30.3 x 25.7cm
© The James Moores Collection
National Portrait Gallery (P298)

John Deakin, 1912–72
Luke Kelly, c.1970
Matt cibachrome print, 29.1 x 26.3cm
© Luke Kelly
National Portrait Gallery (x68944)

David Archer, 1907–71
John Deakin, 1952
Modern print, 19 x 22cm
© The James Moores Collection

Muriel Belcher, 1908–79
John Deakin, 1960s
Modern print, 20.5 x 20.5cm
© The James Moores Collection

Left to right: Robert MacBryde, 1913–66
and Robert Colquhoun, 1914–62
Felix H. Man, 1949
Illustrated in *Picture Post*, 18.9 x 23.5cm
© Reserved

Brendan Behan, 1923–64
Sir David Low
Pencil, 20.3 x 15.6cm
© Reserved
National Portrait Gallery (4529 (22))

Gaston Berlemont, born 1914
Joëlle Dépont, 1989
© Photo Joëlle Dépont/*The Sunday Times*

Colin MacInnes, 1914–76
John Deakin, mid 1960s
Bromide print, 25.3 x 20.5cm
© The James Moores Collection
National Portrait Gallery (P297)

Daniel Farson, 1927–97
John Deakin
Snapshot print, 17 x 19cm
© Estate of Daniel Farson

Ronnie Scott, 1927–96
Philip Sayer, 1991
Colour print, 20.3 x 15.2cm
© Philip Sayer

George Melly, born 1926
Lewis Morley, 1960s
Bromide print, 19.6 x 24.3cm
© Lewis Morley/Akehurst Bureau
National Portrait Gallery (P512(15))

Jeffrey Bernard, 1932–97
Trevor Leighton, 1990
Bromide print, 30.3 x 22.8cm
© Trevor Leighton
National Portrait Gallery (x35308)

Richard Ingrams, born 1937
Lewis Morley, 1966
Bromide print, 38 x 28.8cm
© Lewis Morley/Akehurst Bureau
National Portrait Gallery (x38961)